SIERRA
STARLIGHT

SIERRA
STARLIGHT

The Astrophotography of Tony Rowell

Foreword by Kenneth Brower

Heyday, Berkeley, California

Library of Congress Cataloging-in-Publication Data
Rowell, Tony.
 Sierra starlight : the astrophotography of Tony Rowell / Tony Rowell ; foreword by Kenneth Brower.
 pages cm
 ISBN 978-1-59714-313-4 (pbk. : alk. paper)
 1. Astronomical photography. I. Title.
 QB121.R69 2015
 522'.63--dc23
 2015000327

Front cover photo: The eastern Sierra above Lake Sabrina.
Back cover photo: Geminid meteor, eastern Sierra.
Book Design: Ashley Ingram
Map Design: Molly Roy

Orders, inquiries, and correspondence should be addressed to:
 Heyday
 P.O. Box 9145, Berkeley, CA 94709
 (510) 549-3564, Fax (510) 549-1889
 www.heydaybooks.com

Printed in China by Printplus Limited

10 9 8 7 6 5 4 3 2 1

IN MEMORY OF MY FATHER, GALEN ROWELL

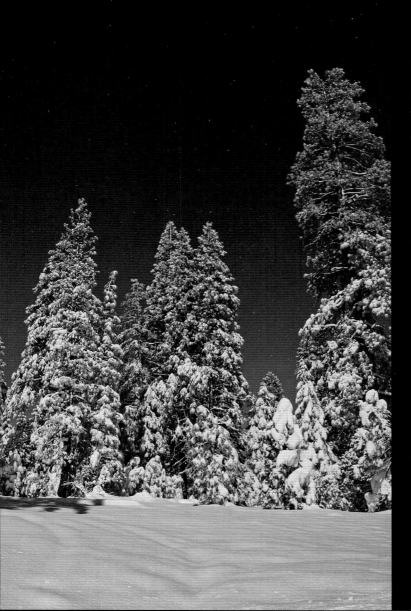

CONTENTS

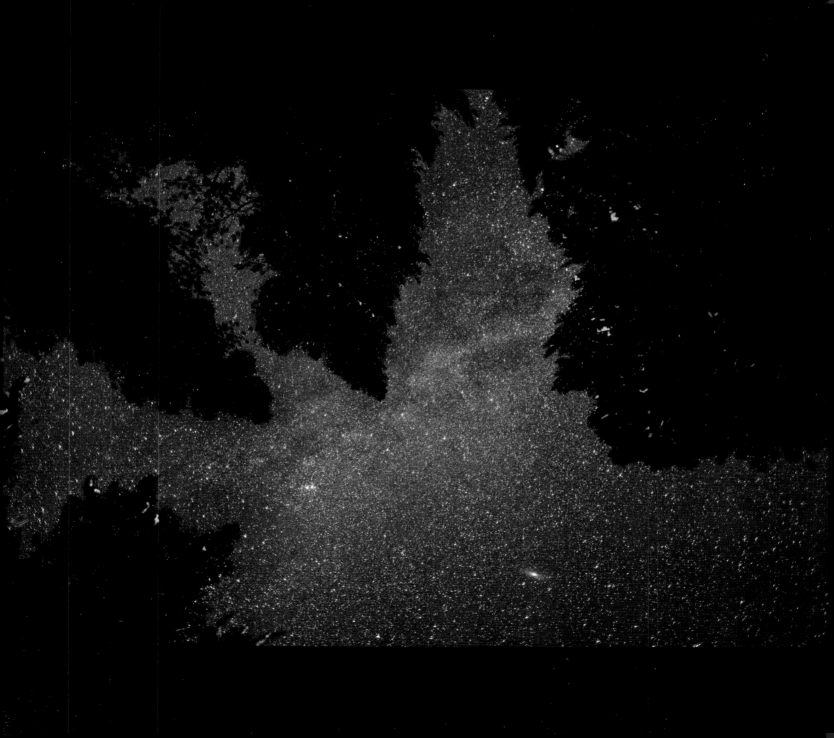

FOREWORD
Kenneth Brower

For a small boy in his mummy bag, above timberline, sleep comes quickly but not before the last moments of consciousness fill with the chill of night and the fierce cold glitter of the constellations above. In the thin air at 10,000 feet, far from the light pollution of any city or town, the stars shine brighter by orders of magnitude and multitude than any he has seen at sea level. Up here the Milky Way is an actual road. It spans a sea of stars that fills the celestial bowl from horizon to horizon. The boy has heard mention of the cosmos, maybe, and has considered it in an idle way, but now in full panoply it slaps him upside the head. Welcome to the universe, young man.

Tony Rowell and I were introduced as children to the Sierra Nevada by two famous rock climbers, our fathers, Galen Rowell and David Brower. This makes for a kind of fraternity and gives me license to speculate on the true origin of Tony's book. I am nearly certain it went like this: He was that boy in a mummy bag under the stars. The goose-down bag was drawn tight about his face for warmth, only his eyes, nose, and cheeks exposed. His cheeks were icy. It was not simply *as if* the cold of interstellar space had dipped closer to Earth to breathe the breath of the void on his face. The cold of interstellar space had actually dipped closer. At this elevation, the atmosphere, our only shield for deflection of cosmic rays and solar winds and the breath of the void, is diminished by a third. He promised himself that tonight he would stay awake. He would open his mind to the firmament. He would not close his eyes until he had seen at least one shooting star. Often sleep overtook him before this happened. Other times a meteor would trace its arc across the stars and he would wait for another.

This is how it was for me, anyway. I'm guessing it was the same for Tony. Why, I wonder, could I never keep my eyes open for more than two minutes or three? In part it was the child's talent for sudden sleep. In part it was weariness from the day's hiking. But in part, too, it was strategic withdrawal, a reaction to a kind of overpressure from the infinity above. My eyes closed to shut out eternity and impossible distances and the scintillation of a starry endlessness that does not care.

Malcolm Margolin, our publisher, is smitten by Tony's astrophotography, seeing it as a new way of looking at the Sierra. So it is, and yet at the same time it is very old. (If there is nothing new under the sun, then there is also nothing new under the stars.) Tony's long exposures, steadied by his motorized Celestron star-tracking telescope mounts, approximate the light-gathering capabilities of owls, bobcats, cougars, and ringtails. For the night creatures of the Sierra Nevada, the world is bathed in this same sort of amplified starlight and moonlight. The images in this book are metaphors, at very least for that nocturnal way of seeing.

Migrating birds, like Tony's camera, focus on the constellations. We know this because European and American ornithologists, using planetariums and taking advantage of the bird behavior that Germans call *zugunruhe*, "migratory restlessness," have conducted illuminating experiments on celestial navigation in birds. When the night skies of spring and fall are projected on a planetarium dome, they stimulate the migratory urge in caged birds. The birds flutter and hop in the normal direction of migration for whichever season is projected. Migratory birds are particularly interested in the region of the northern sky in the vicinity of Polaris, the North Star. Polaris is the calm eye around which each night's slow celestial hurricane wheels. The birds orient themselves in relation to that fixedness. They align with the *principle*, at any rate. If the planetarium is programmed so that the night sky revolves around the star Betelgeuse, instead of Polaris, the birds will orient in relation to Betelgeuse.

Tony Rowell, like the birds, is obligated to maintain his polar alignment. The great frustration of his early astrophotography, he tells us, was in learning how to keep his scope centered on the north celestial pole, in the vicinity of Polaris, to avoid star trails in his long exposures. The difference is that the birds have had more practice. In the longest cycle we know, every 26,000 years, the star Vega takes the place of Polaris at the north celestial pole, and evolution, after many repetitions of this cycle, has imprinted the birds with the importance of the stillness at the center of the vortex of stars. Tony, for his part, has had to start from scratch. But he has the hang of it now, and he and the migrants are birds of a feather. The images in this book will be of great interest to snow geese and arctic terns and phalaropes.

These photographs would have gripped our ancestors, too. They are a throwback to an older *human* way of seeing. The stars were once our familiars, but no longer, not since the invention of electricity. Close acquaintance with the constellations is now confined to specialists and mediated by

instruments, whereas through most of history, and all prehistory, the stars belonged to everyone and to the naked eye. Sun and stars told us when to plant, when to expect the salmon and bison and waterfowl, when to stage the festivals celebrating the equinoxes and solstices.

Starshine steered our migrations. The last great expansion of humanity into a big uninhabited portion of the globe—the settlement of the Pacific Ocean—began seven thousand years ago and was accomplished by a system of celestial navigation so ingenious that it lasted well into the twentieth century. Finally, in the 1940s and 1950s, the star compass of the islanders faded fast, losing out to the magnetic compass. The old system survives whole and intact in only two small places, the atoll of Puluwat and the island of Satawal, both in the Central Caroline Islands of Micronesia.

My own connection with the stars, begun as a boy amidst 14,000-foot peaks, resumed on the coral island of Satawal, which stands just seven feet above the sea. (The Satawalese are fascinated by the concept of mountains, for they lack even the semblance of *hill*. They are uneasy about the concept of snow, which has never fallen, not a single flake, on their equatorial island.) In my twenties I hitched rides on the outrigger canoes of Satawal. The Satawalese navigator has less in common with Magellan or Captain Cook—with the astrolabe and the sextant—than he does with the inertial navigation system in an aircraft carrier. Reading the stars, the swells, and the behavior of birds, calculating leeway—wind drift—and guessing at current drift, measuring canoe speed by mental reference to unseen islands and reefs beyond the horizon, the navigator keeps continuous track of the canoe's position on the sea. In an apprenticeship that can last thirty years, he memorizes, with the aid of mnemonic chants, the "star courses" between every pair of islands in the west-central Pacific. The Satawalese name for Polaris is Feusamakut, "The Star That Never Moves." First the birds took note of this polar steadiness, and then the ancient navigators, and finally Tony Rowell.

There many photographs of meteors in this book—too many, I thought at first. I've changed my mind. Nothing could be more dramatic than these quick incinerations. A small object that has hung in interplanetary space for 4.5 billion years, ever since the formation of the solar system, suddenly encounters something else—our atmosphere—and burns up in a second. Tony's meteor images are not truly repetitious, for in fact no two meteoroids are the same. We know now, from close NASA flybys of various planets and moons, and from landers sent down to asteroids and a comet, and from meteorites retrieved from Antarctic ice, that every object in the cosmos, no matter how small, is unique

and surprising. Some meteors flame out after a few moon-widths across the sky. Others streak from horizon to horizon. Shooting stars, like real stars, burn in different colors. Each luminous trail marks the disappearance of something that will never come this way again.

Tony's father and stepmother, Galen and Barbara Rowell, crashed and died in a small plane in a night flight over the Sierra Nevada. Contemplating the meteors on Tony's contact sheets, one after another, I found myself wondering: could his father's fall from the sky have something to do with his preoccupation with this subject? Astrophotography as autobiography?

Yes and no, Tony advises. He was already a photographer of meteors at the time of the crash. For the nine years prior, his ritual was to take every August 12 off from work to shoot the Perseid meteor shower. This shower, one of our brightest, is made up of youngish meteoroids, tiny fragments of the comet Swift-Tuttle scarcely a thousand years old. Perseids means "Sons of Perseus," for the meteors appear to radiate from the constellation Perseus. The shower peaks each year between August 9 and 14, when the meteor rate rises to around sixty each hour. On August 11, 2002, the night before Tony's traditional rendezvous with the Perseids, Galen Rowell's plane fell amidst those falling stars. On this day ever since, for Tony, the constellation Perseus radiates meteors and memories of his father.

Galen Rowell was a friend and colleague of mine. We grew up a block apart in Berkeley and attended the same elementary school and high school, Galen four years ahead of me. Throughout his life he had a crazy energy. A month before he died, Galen, at the age of sixty-one, accompanied by the Himalayan super-climbers Conrad Anker, Jimmy Chin, and Rick Ridgeway, was pulling a heavy sled across the Chang Tang Steppe of Tibet. His early death, by pilot error, after innumerable close calls climbing peaks and running rivers, is hard to reconcile. In an obituary I wrote long before I saw any of Tony's night photographs, I described his father's path as meteoric.

Each meteor trail marks the extinction of something we will never see again. A boyhood sense of this explains, maybe, my old rule in the sleeping bag: at least one shooting star was required before I shut my eyes against the cosmos. Small eternities would pass without a meteor. The brilliance of the stars burned into the emulsion of memory like nothing I can recall from hours on the trail by daylight. The glitter was inexpressibly beautiful and it was daunting. The mind shied from the inconceivable temperatures at which stars burn, from the profound cold through which they shine, from the fathomless depths of space and time that separate them, but I forced my eyes to stay open. I waited for the bright passage of something ephemeral, like us.

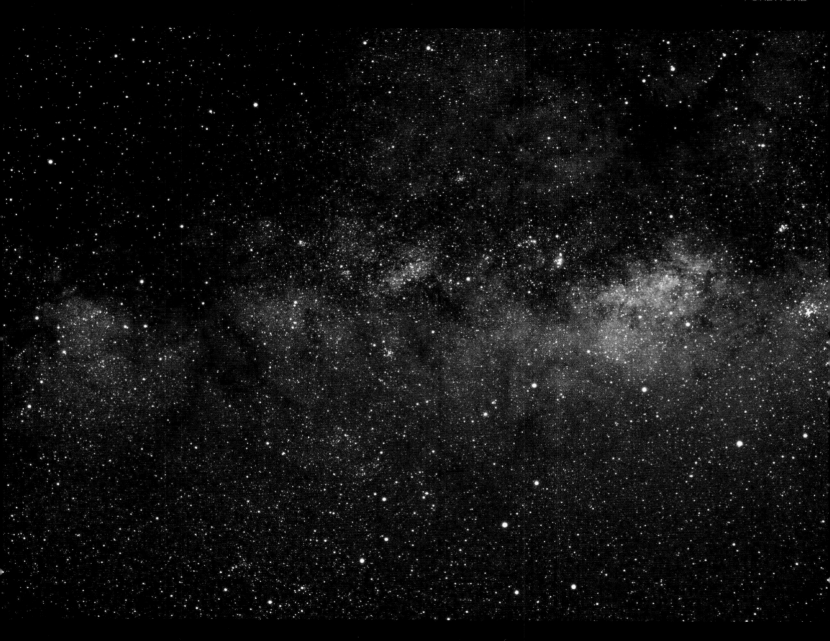

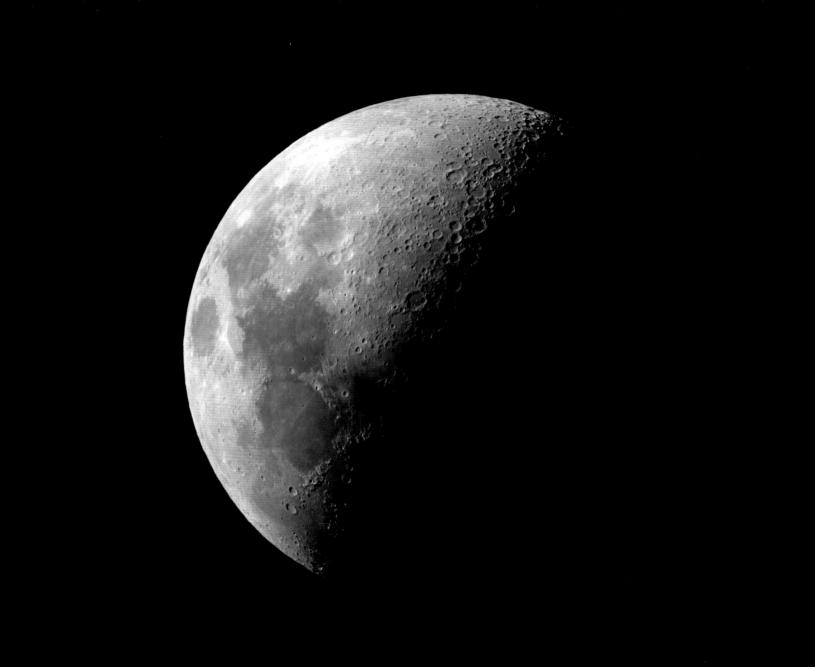

PREFACE
The Art of Astrophotography

Astrophotography is a word that we seldom hear or read; however, this photography technique was used soon after the first image was recorded. In fact, astronomer Sir John Herschel was the first to use the term *photography* in 1839, and the first to use "negative" and "E2 positive" in relation to photography. A year later, photochemist John William Draper was the first person to take a properly exposed astrophoto, an image of the moon. In the early 1920s, renowned astronomer Edwin Hubble used astrophotos he captured through a 100-inch telescope of what was then called the Andromeda Nebula to prove that Andromeda was a galaxy and that the Milky Way wasn't the only galaxy in the universe. One of the most powerful nature photographs ever made was of the earthrise over the moon, taken in December 1968 by Apollo 8 astronaut William Anders on the first manned mission to orbit the moon. This photo greatly inspired my father, photographer Galen Rowell. He called it "the most influential environmental photograph ever taken." When he met Anders in 1978, my father had him sign a print of his earthrise photo for me. I was ten years old.

In his book *Mountain Light*, my father mentions his own astrophotos, including moonrises, moonlit scenes, and star trails over mountain landscapes. From 1990 to 2001, I photographed many celestial subjects with my father, including the aurora borealis in the Arctic and the Milky Way in the White Mountains above his home in Bishop, where he established his gallery and offices, Mountain Light Photography. My dad considered the Sierra Nevada and the surrounding areas to be one of the most beautiful places in the world. The region is also home to one of the darkest night sky areas in the Lower 48 states. Relatively low light pollution results in exceptional astronomical viewing. In those early days, I used 35 mm film cameras mounted on tripods, exposing for several minutes to capture star trails over landscapes.

In 2003, a year after my father and my stepmother, Barbara, died in a plane crash, I purchased a vacation home in Bishop. Over the years I've attended a few of Mountain Light Photography's workshops, always led by talented photographers. Both the Sierra and the practice of photography have never been far from my mind.

I now use motorized telescope mounts and various cameras to track the stars and planets in long single-frame exposures. With digital cameras the exposures can be shorter, as the camera can collect the necessary light more quickly. I usually photograph around the time of the new moon when the sky is the darkest, weather permitting. I joke with my friends that I'm putting in nine-to-five days, but my hours are nine p.m. to five a.m. To add dimension to my celestial images, I use light-painting techniques that I learned from my father. During the last few seconds of my single exposures, I use flashlights and off-camera flashes to illuminate subjects in the foreground. I call the resulting images "astroscapes."

There are many methods of taking astrophotos of the cosmos. The easiest is to take wide-field exposures from a fixed tripod, which usually results in the stars trailing unless you keep your shutter open for thirty seconds or less with a 28 mm lens or wider. Another technique is called piggyback photography, where you need to have a camera equipped with a bulb setting and cable release to lock the shutter open. With our planet rotating fifteen degrees every hour, your camera has to be on an equatorial mount in order to track nebulas and other deep-space objects. The learning curve for me with this technique was frustrating, and it required many late nights to perfect the polar alignment (keeping the scope centered on the north celestial pole, which is near the north star, Polaris), but once I made it through what I call astro–boot camp, the images I captured were very rewarding.

One of the most popular astrophotography techniques is prime-focus photography, which involves using a T-ring (an adapter that connects your camera to a telescope) to take deep-sky photos of galaxies, nebulas, and planets using a telescope as a telephoto lens. Photographers using film have to bracket, while those using digital cameras have the advantage because they can figure out the correct exposure right away. Also, using film often requires a complex series of steps to make the film hypersensitive so the faint starlight will make an exposure. Digital cameras, which can operate at extremely high ISOs, give one a distinct edge here too. A few potential challenges with prime-focus photography are vignetting in the corners of images and getting the focus just right. Digital cameras allow you to

see relatively quickly whether you actually got the image you set out to create. Many a film shooter has left a night of astrophotography only to find that none of the images came out, while digital photographers are able to evaluate, adjust, and reshoot during the night.

In 2008, while writing an astrophotography article for *Outdoor Photographer*, I drove through Yosemite on my way home to Bishop and was fortunate to meet David Rodrigues, an astronomer known as the Astro-Wizard. When I told him I was planning on doing some astrophotography that week, he invited me to join him and several members of the Eastbay Astronomical Society at the Barcroft High Altitude Research Station located in the White Mountains at 12,450 feet. Halfway through my drive the next evening, I passed the bristlecone pine grove where a few months earlier I had captured one of my best images, of the Milky Way rising over an ancient tree that's said to be thousands of years old.

After passing 8,000 feet, I arrived, met the group, and began aligning my scope with the north celestial pole. Barcroft was the best and darkest location I've photographed from, though the temperature dropped to a chilling twenty-five degrees that night. I captured the Milky Way and Andromeda galaxies on film using my father's Nikon F100 with a 300 mm $f/2.8$ lens. The next day, marine biologist and astrophotograher Chris Kitting showed me his images taken with his new digital Nikon D700, and was impressed with the image quality and how little digital noise he achieved with his camera's higher ISOs. He was very pleased with the D700 and inspired me to buy one of my own. I never used my film camera again, and a few years later I purchased a larger 36 MP Nikon D800E.

I became so immersed in the art of astrophotography that I moved away from the San Francisco Bay Area into my Bishop vacation home. For more than three years I made repeated trips to iconic landmarks in and around the Sierra Nevada and filmed them under stars and by moonlight, making a time-lapse movie and amassing stills for this book. Nothing stopped me: not bad weather, nor sleep deprivation, nor seventy-five-pound packs, nor wild animals (including a few bears).

The images included in this book are only a handful of the tens of thousands I've taken of these areas. I have captured comets, meteors, lunar rainbows, planets, nebulas, and the stars of our Milky Way galaxy. I'll leave it to John Muir to express in words what I aim to convey in these photos: "When one is alone at night in the depths of these woods, the stillness is at once awful and sublime."

This introduction is an edited and expanded version of an article the author wrote with the same title for *Outdoor Photographer* in July 2009.

TAHOE

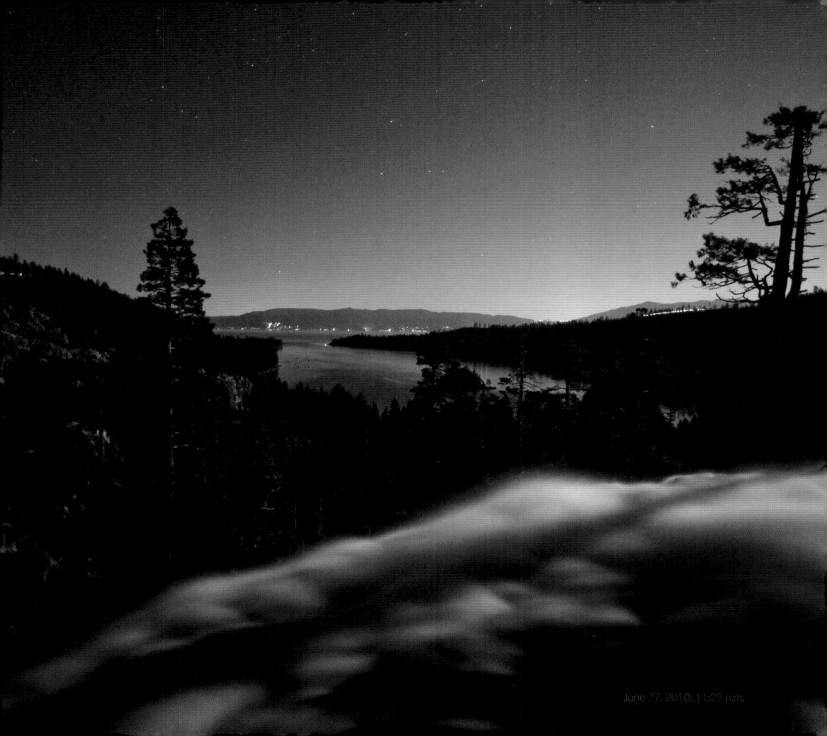

June 27, 2010, 11:29 p.m.

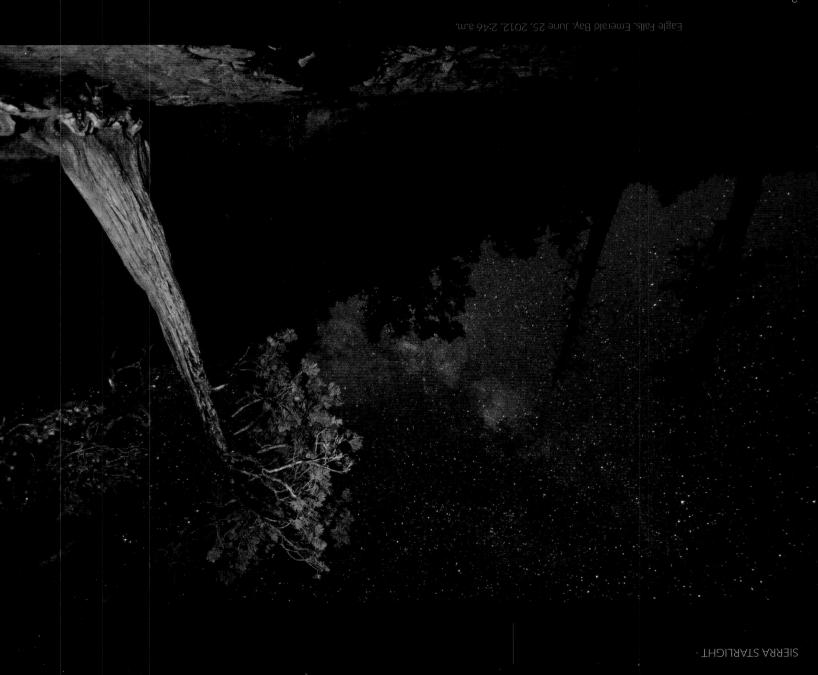

Eagle Falls, Emerald Bay, June 25, 2012, 2:46 a.m.

At 2:00 a.m., when the world is still, dark, and cold, I'm hiking out to a photo shoot with friends or, on many occasions, alone. When I am alone under the stars I feel a heightened awareness. Several years ago I used to get nervous when hiking alone in remote areas, but now I embrace being accompanied by the call of distant coyotes and the rustle of nocturnal animals in the brush. Even though I'm dwarfed and rendered insignificant by the billions of stars, I don't get lonely. I watch for meteors during the two or three hours when I am shooting time-lapse videos, and I imagine what types of life, if any, might be out there in the vast universe.

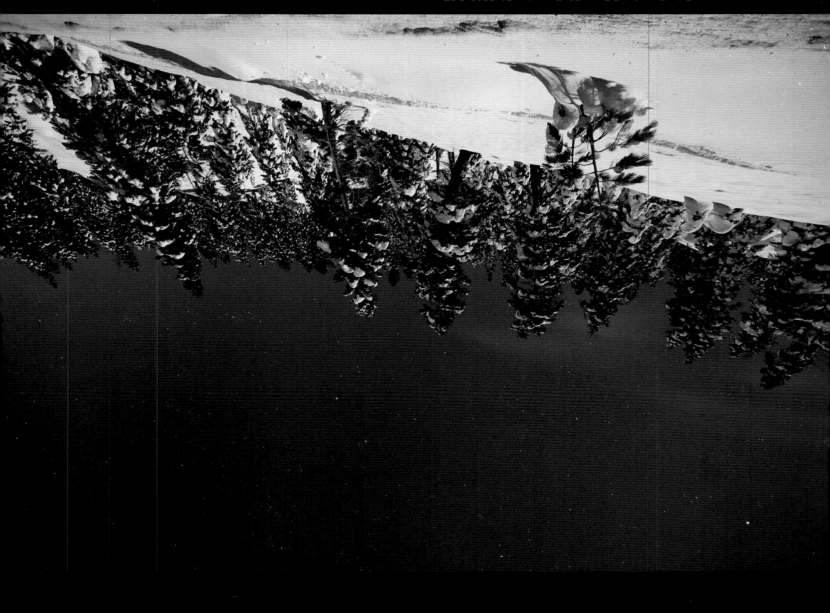

Echo Summit, US Route 50, December 31, 2012, 3:07 a.m.

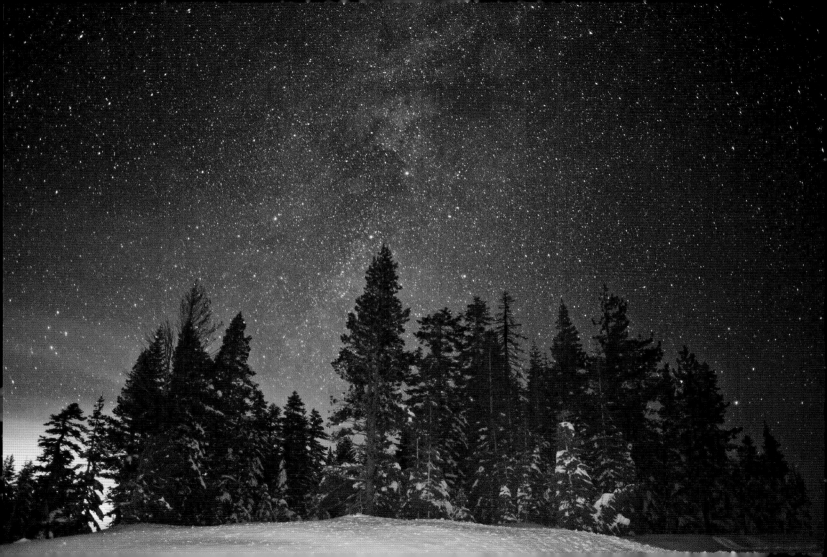

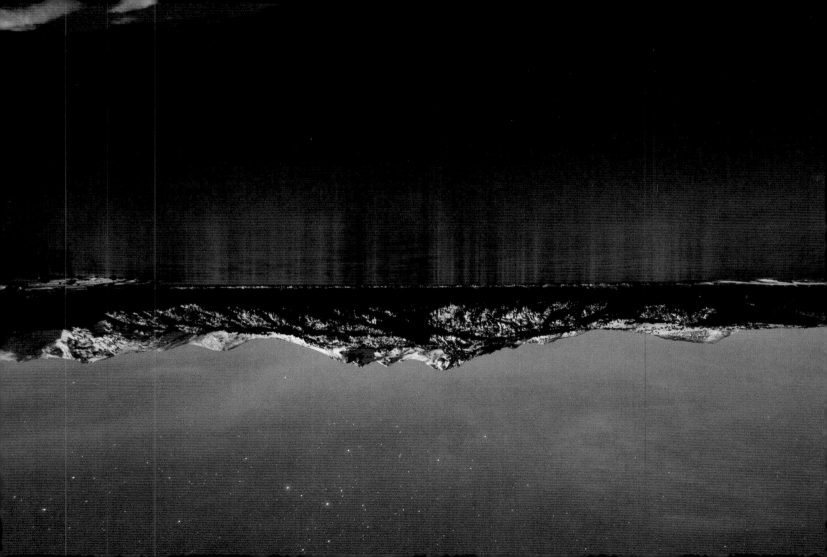

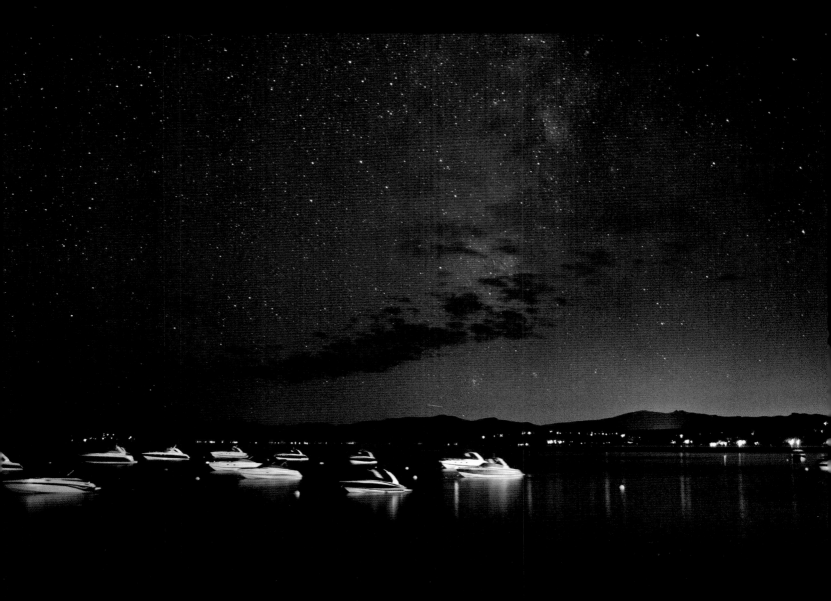

Lake Tahoe, September 11, 2010, 10:30 p.m.

YOSEMITE

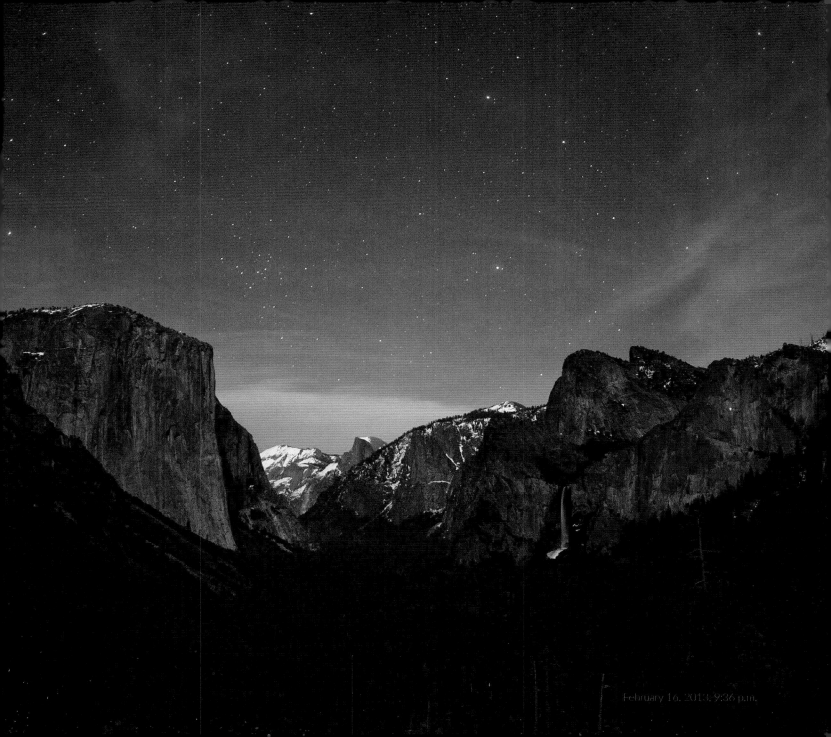

February 16, 2013, 9:36 p.m.

Moonbow at Yosemite Falls, May 30, 2010, 1:31 a.m.

Light reflected off the surface of the moon and then refracted off waterfall mist can yield a rare lunar rainbow, or moonbow, at Yosemite Falls. The colors aren't visible to the naked eye but show up on film or digital exposure. This phenomenon can only be imaged during conditions of clear, cloudless evenings with bright, unimpeded moonlight and a spring snowpack that produces peak falls.

In May of 2010, conditions were supposed to be ideal on and around the full moon. After waiting a few days for a storm to clear, I decided to drive to Yosemite Valley. The drive usually took about three and a half hours entering from the East Gate, but unfortunately Tioga Pass Road was still closed, so I had to take a seven-hour drive from my home in Bishop and enter the park from the South Gate near Wawona.

I arrived during the busy Memorial Day weekend without making reservations or having a place to stay. I knew that my friend, renowned time-lapse photographer Tom Lowe, might be camping there that weekend, so I gave him a call and he generously invited me to stay at his camp. I had taken still images of the moonbow the previous year, but this year Tom inspired me to shoot a time-lapse video consisting of over three hundred photos. It was past midnight by the time I set up my camera beneath North America's highest waterfall. In the early morning I was rewarded with a vivid multicolored moonbow with bright stars over both the upper and lower falls. Never before and never since have I captured a moonbow so clear and so stunning.

Nikon D300s; Nikkor 24 mm f/2.8 lens at f/4; 20-second single exposure at ISO 800; mounted on Gitzo G1228 carbon-fiber tripod

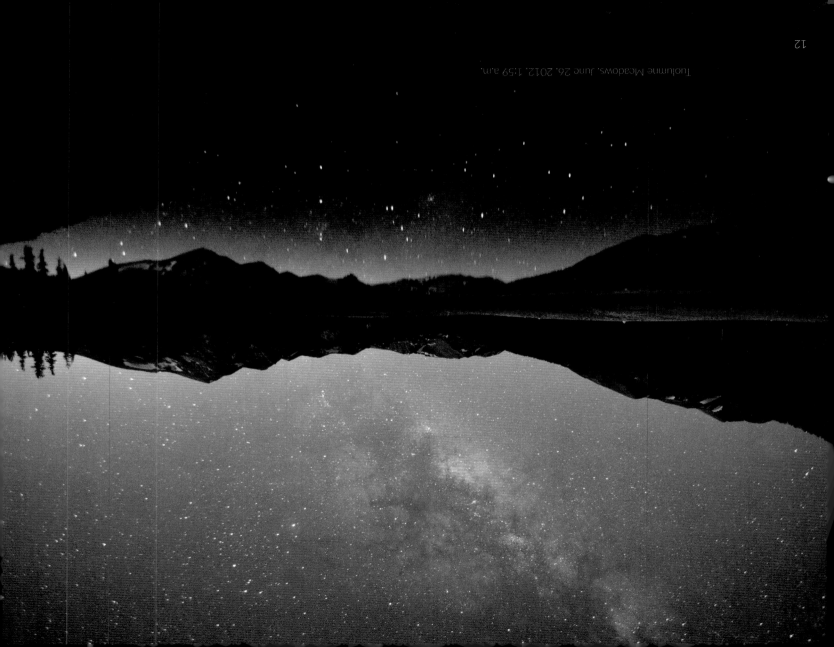

Tuolumne Meadows, June 26, 2012, 1:59 a.m.

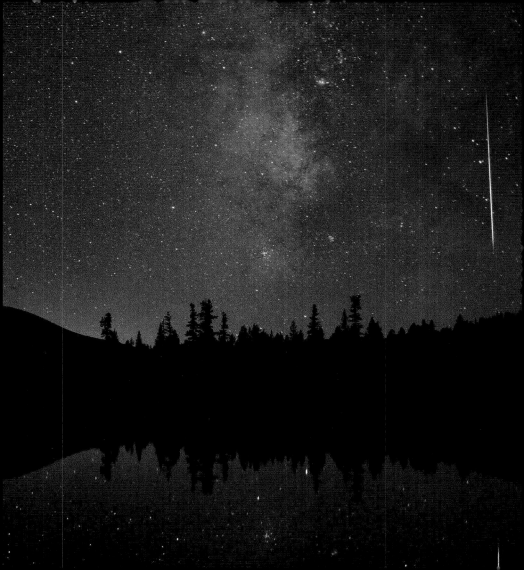

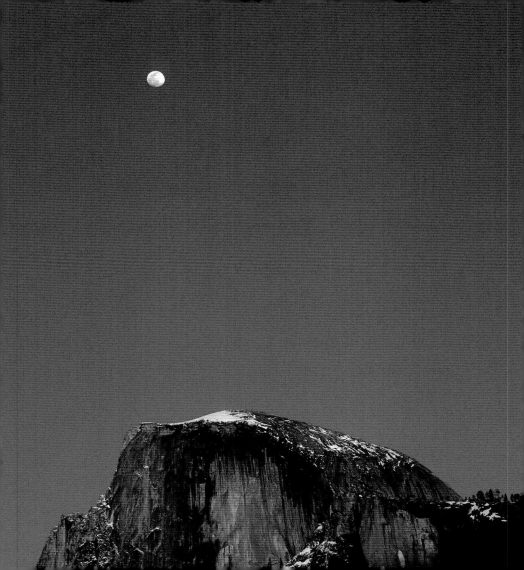

June 16, 2012, 4:28 a.m.

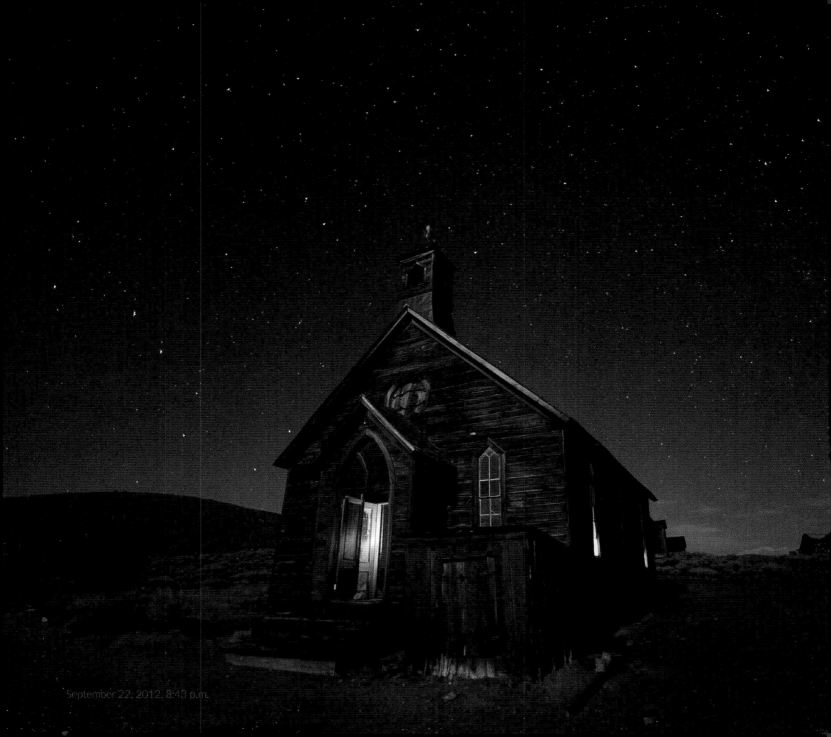

September 22, 2012, 8:43 p.m.

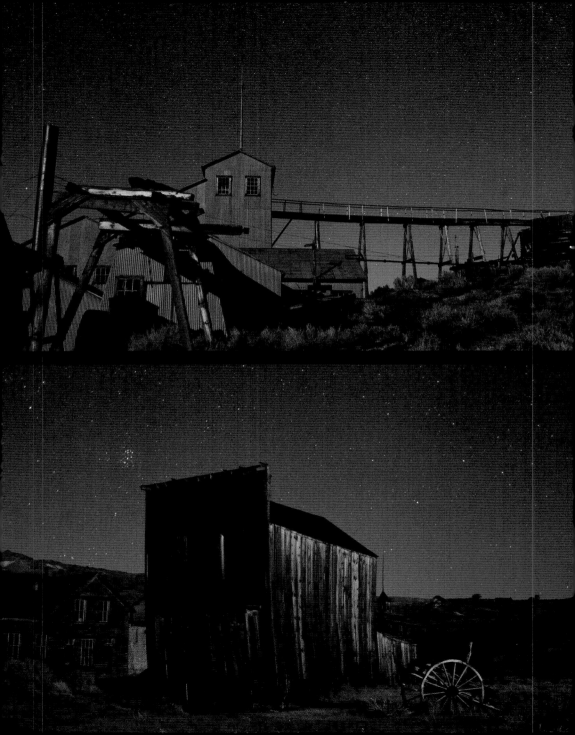

September 22, 2012, 8:15 p.m.

MONO
LAKE

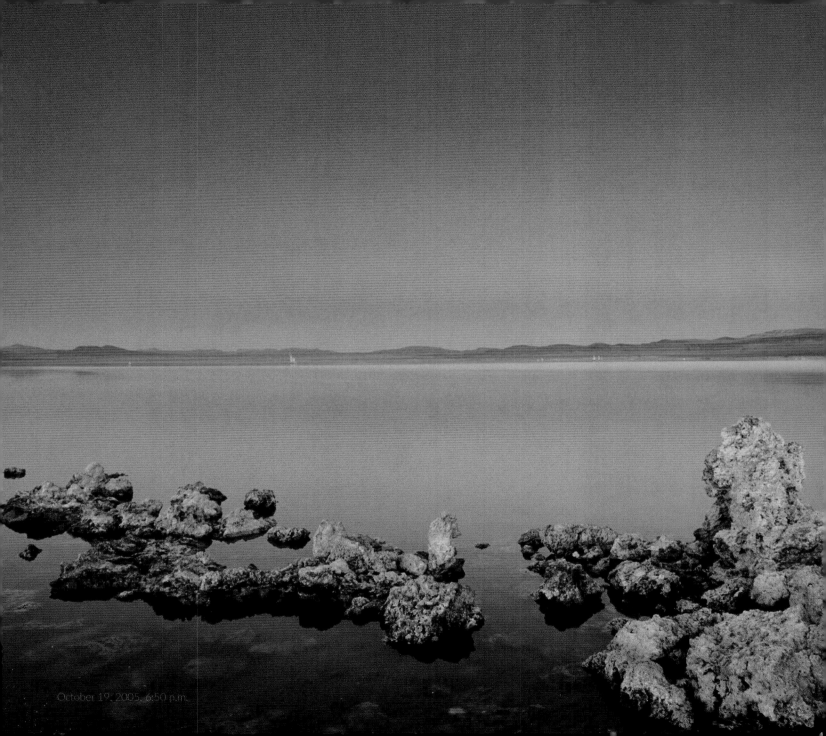

October 19, 2005, 6:50 p.m.

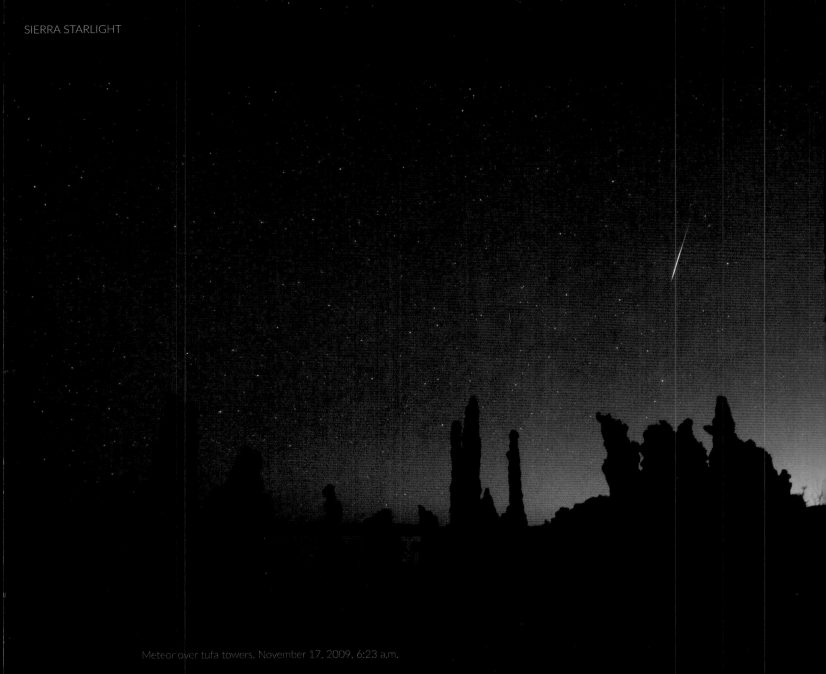

Meteor over tufa towers. November 17, 2009, 6:23 a.m.

In November 2009 my friend Sean and I traveled to Mono Lake in California's eastern Sierra to photograph the annual Leonid meteor shower over the dramatic tufa columns that rise up from the lake like petrified spires. These tall limestone formations are typical of hyper-saline lakes like Mono Lake, one of the oldest lakes in North America. That evening we both sighted dozens of meteors in the night sky, but after several hours of braving the thirteen-degree temperature I had only caught a few streaking through my photos. Daybreak was approaching and Sean was ready to leave, but I convinced him to stay for just a few more images. Just before dawn our patience paid off when I captured a bright meteor above silhouetted tufa rocks on the shoreline of the lake. A few days later the image was chosen as the Astronomy Picture of the Day on NASA's APOD website.

Nikon D700; Nikkor 24 mm f/2.8 lens at f/5.6; 38-second single exposure at ISO 1000

June 18, 2010, 3:52 a.m.

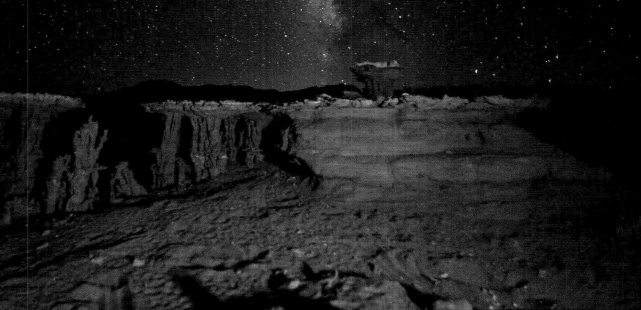

Sand tufas at Navy Beach. August 21, 2011. 11:09 p.m.

MAMMOTH MOUNTAIN

Orion over Mammoth Mountain, February 23, 2011, 12:31 a.m.

January 4, 2011, 3:29 a.m.

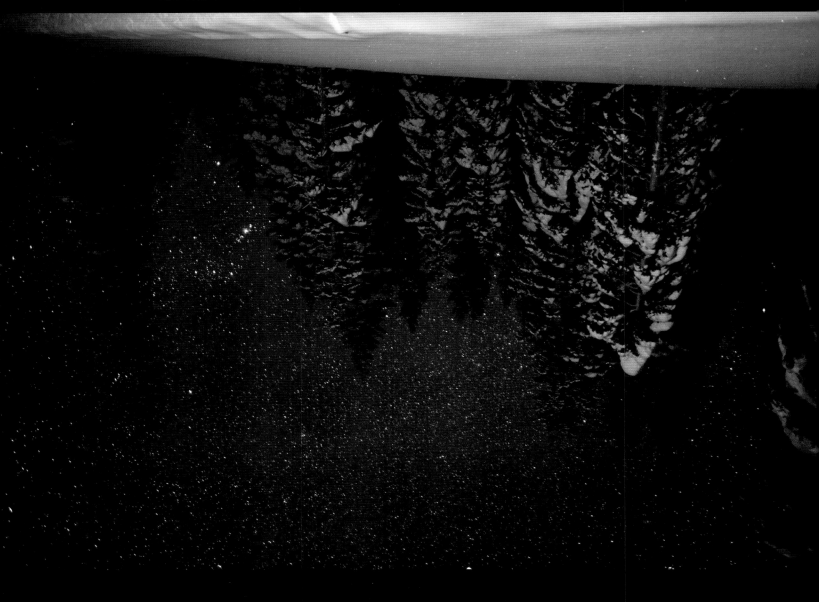

WHITE
MOUNTAINS

August 18, 2013, 8:01 p.m.

June 6, 2008, 1:38 a.m.

The ancient bristlecone pines at Schulman Grove in California's White Mountains are some of Earth's oldest living things. One, named Methuselah, is estimated to be more than 4,700 years old, alive when the Egyptians were building the pyramids. My late father, Galen Rowell, took a stunning image of a bristlecone pine tree with star trails overhead at Schulman in 1976, and this inspired me to challenge myself with a similar shot.

In June 2008, my friend Thomas and I drove to the grove, arriving just after midnight. Carrying eighty-plus pounds of equipment, we hiked the 10,000-foot-elevation Discovery Trail up to a tree I'd found on a previous visit. I composed my shot carefully, waiting for the Milky Way to appear parallel to the tree to give the image a strong diagonal. Daytime shooters have to contend with a nearby tree that challenges a strong composition, but at night this smaller tree fades into the background to the left of the bristlecone. With my camera on a motor-driven telescope mount to track the Earth's rotation and keep the stars from trailing, I took a single-exposure shot, using an off-camera flash near the end to illuminate the bristlecone. Nowadays, a twenty-to-thirty-second exposure will do the trick with the higher ISO settings available on newer digital cameras, but at the time I was using film and needed eleven minutes to gather enough light.

Nikon F100; Nikkor 28 mm f/2.8 lens at f/4; 11-minute single exposure; Fuji Provia 400X film, push-processed to 640 ISO; Nikon MC 30 remote; Dorcy 3 Million Candle Power Spotlight using plastic diffuser; Losmandy GM-8 equatorial mount and tripod

The Horsehead Nebula from 12,500 feet, Barcroft High Altitude Research Station, September 7, 2013, 2:56 a.m.

The Andromeda galaxy from Grandview Campground. September 30, 2013, 10:14 p.m.

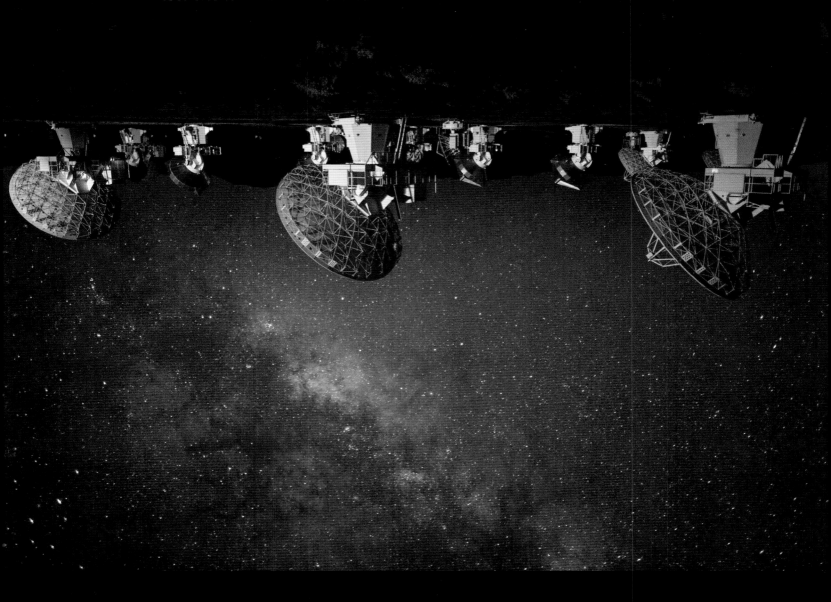

The Combined Array for Research in Millimeter-wave Astronomy (CARMA) Radio Observatory, August 31, 2010, 12:59 a.m.

WHITE MOUNTAINS

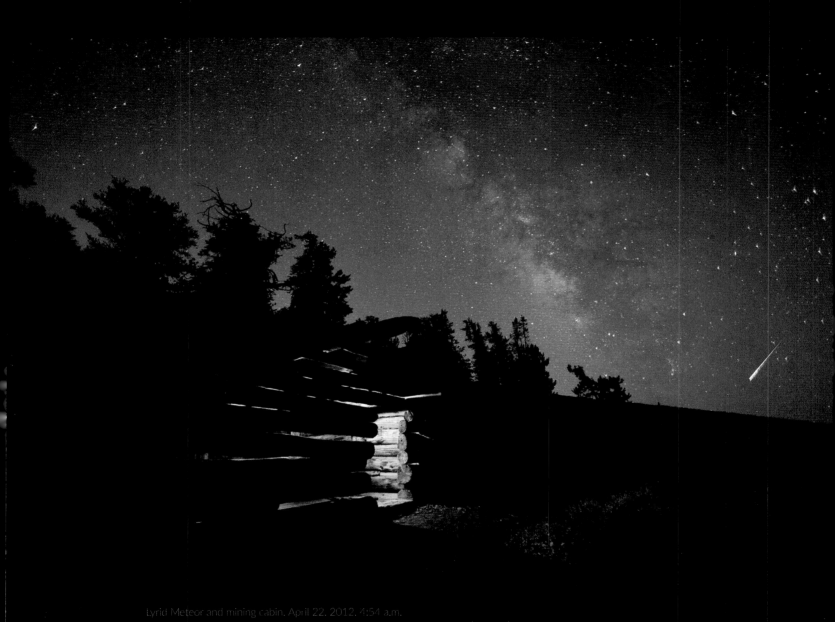

Lyrid Meteor and mining cabin. April 22, 2012, 4:54 a.m.

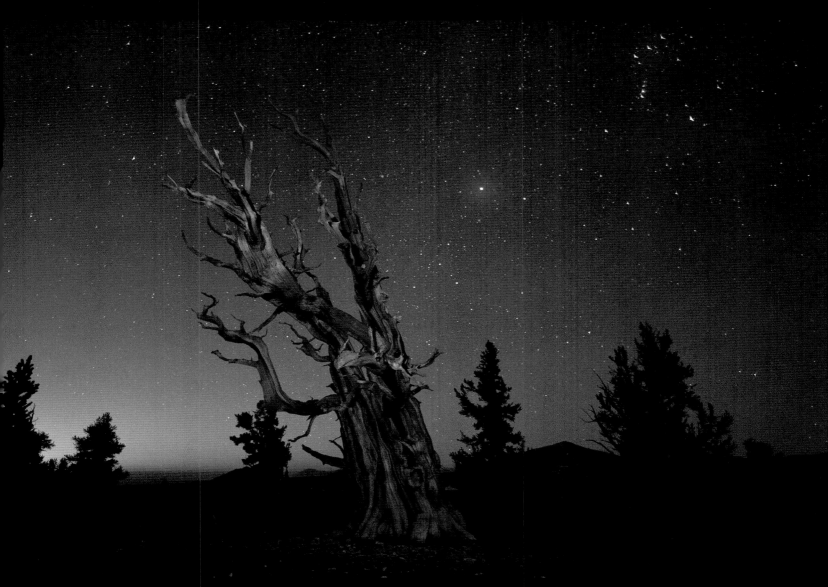

The Patriarch Grove, 11,000 feet. October 21, 2012. 5:59 a.m.

BISHOP

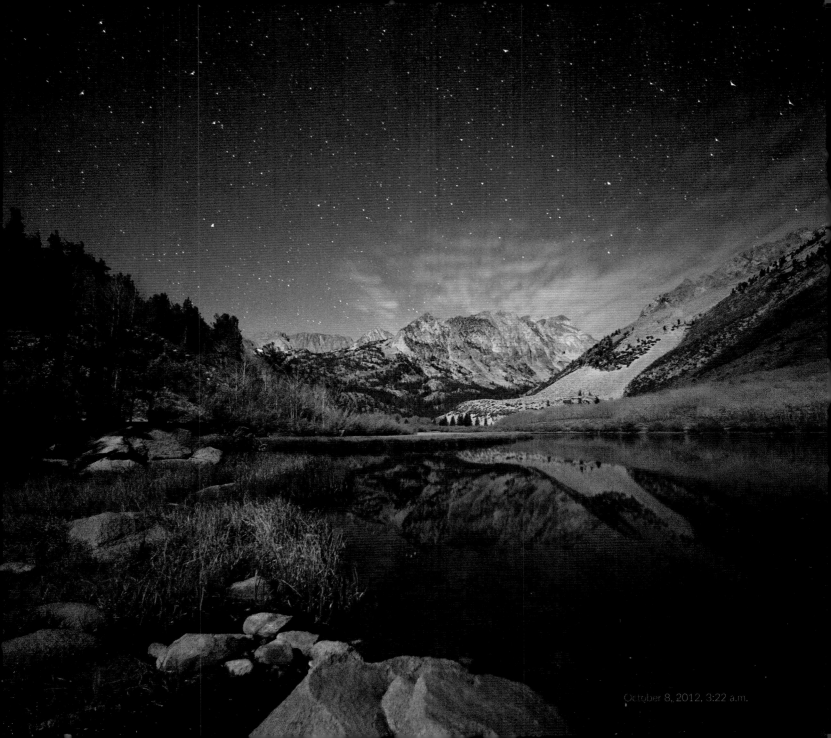

October 8, 2012, 3:22 a.m.

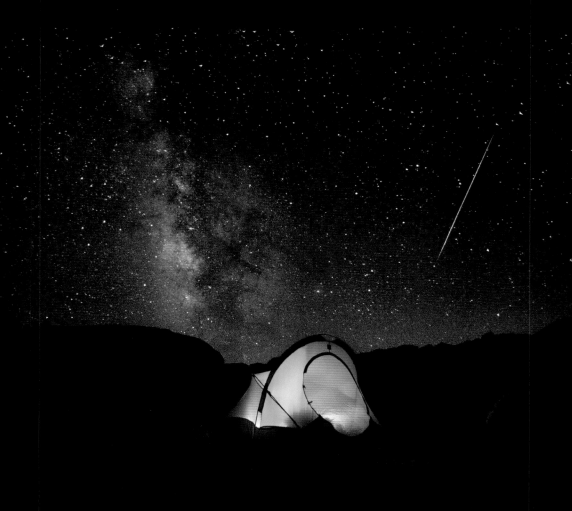

Perseid meteor over campsite, Buttermilk Range. August 3, 2010, 10:58 p.m.

Camping at Coyote Flat above Bishop, July 25, 2009, 9:25 p.m.

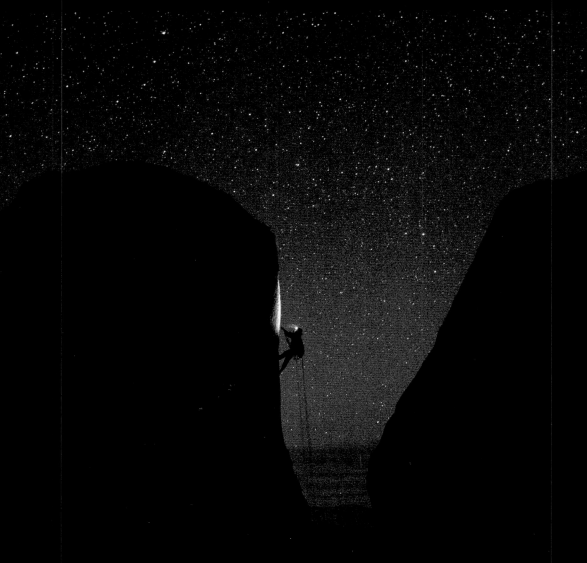

Night climber. Buttermilk Range. April 20, 2012, 9:51 p.m.

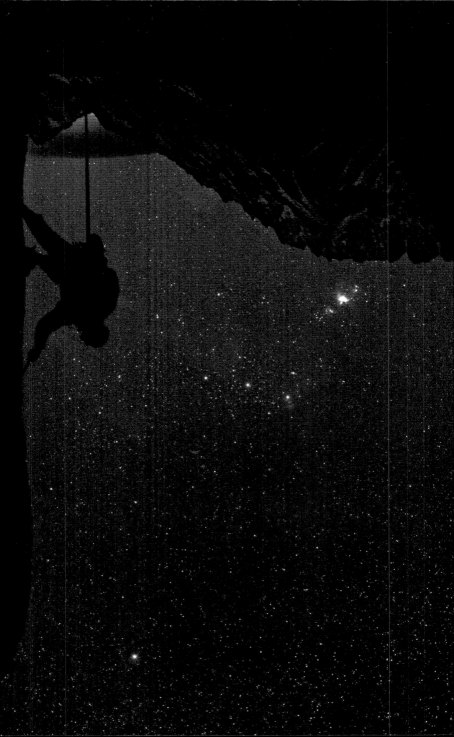

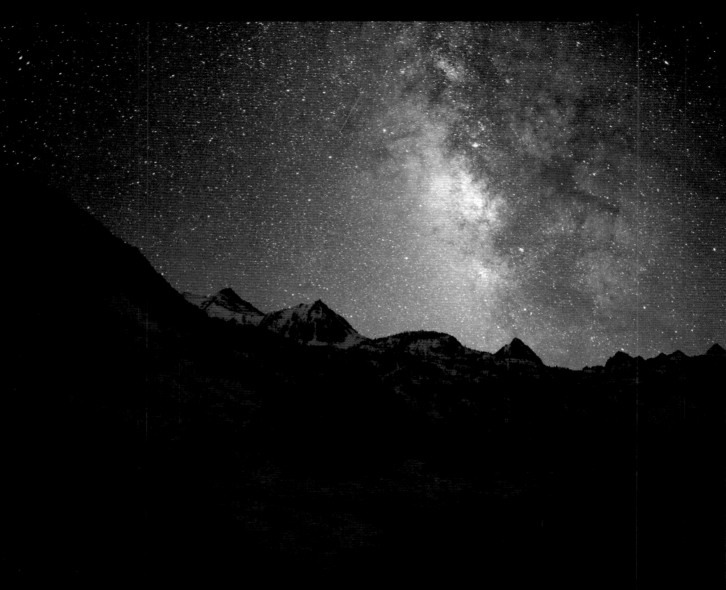

The eastern Sierra above Lake Sabrina, May 15, 2010, 4:17 a.m.

Geminid meteor, eastern Sierra. December 15, 2014, 2:55 a.m.

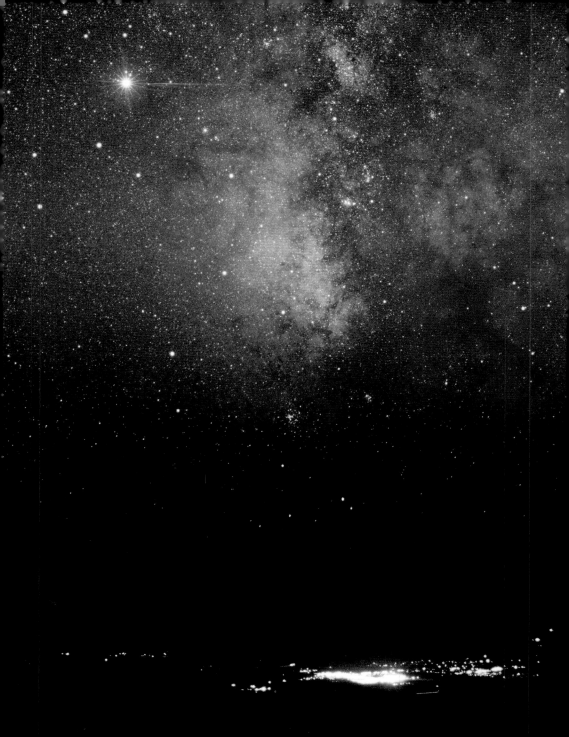

Highway 395, June 16, 2014, 9:30 p.m.

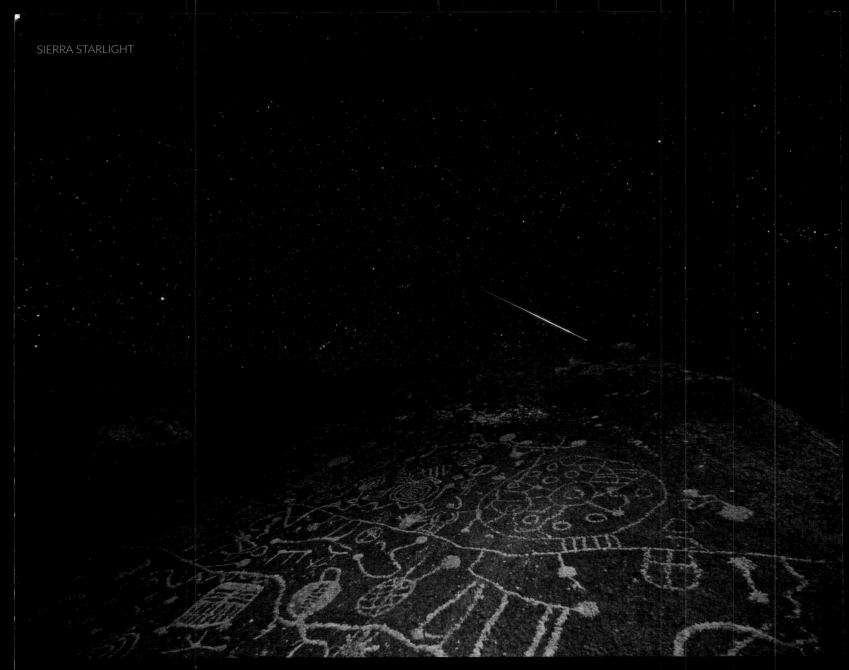

Geminid meteor. December 14, 2013, 4:50 a.m.

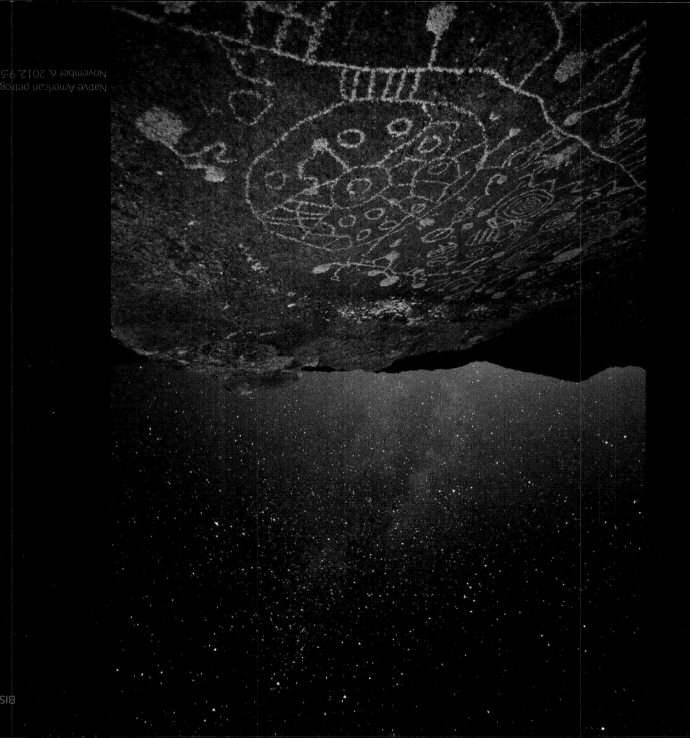

Native American petroglyphs.
November 6, 2012, 9:56 p.m.

MOUNT WHITNEY

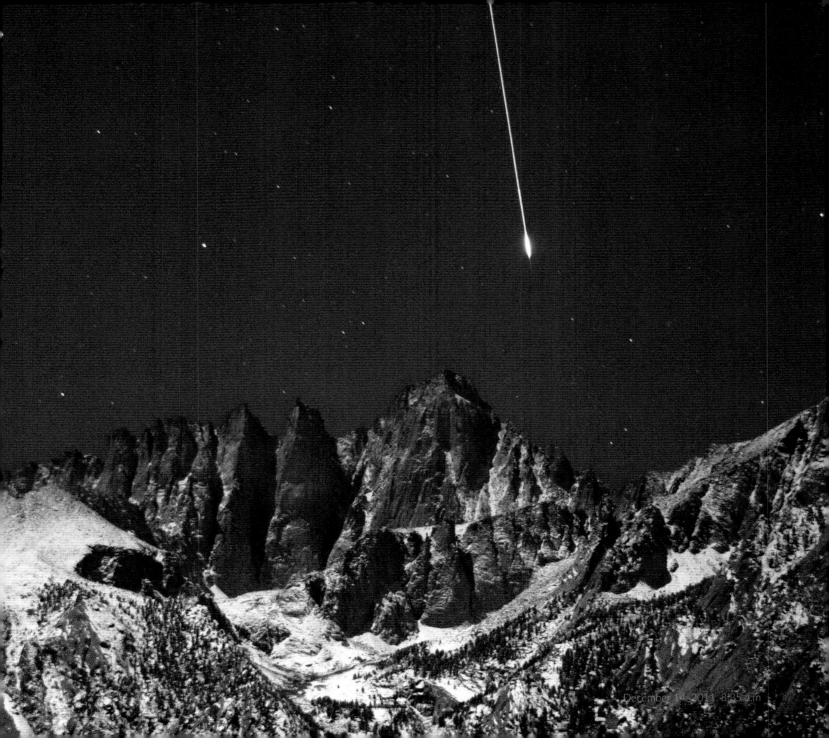

December 14, 2011, 8:35 a.m.

ALABAMA
HILLS

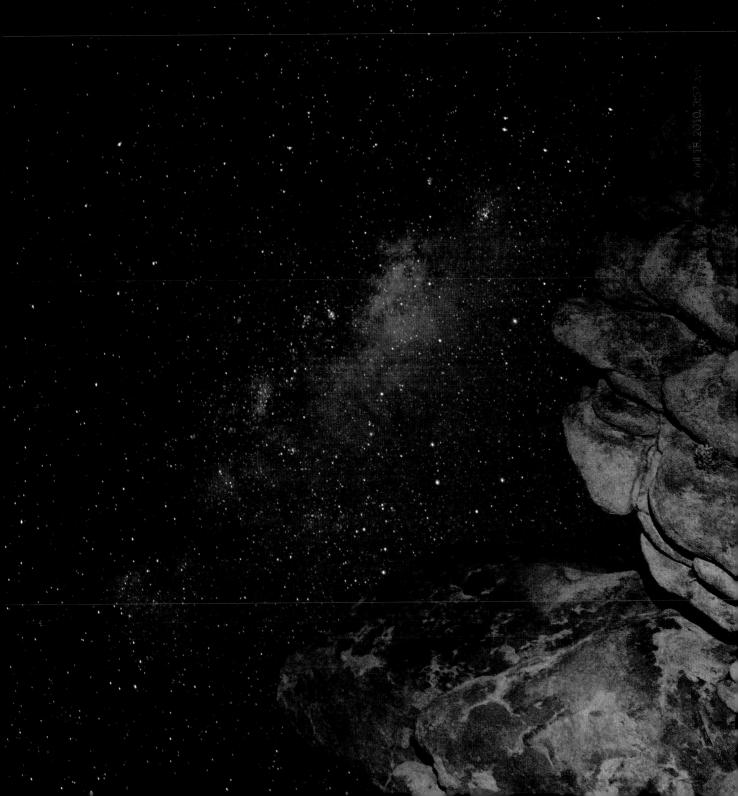

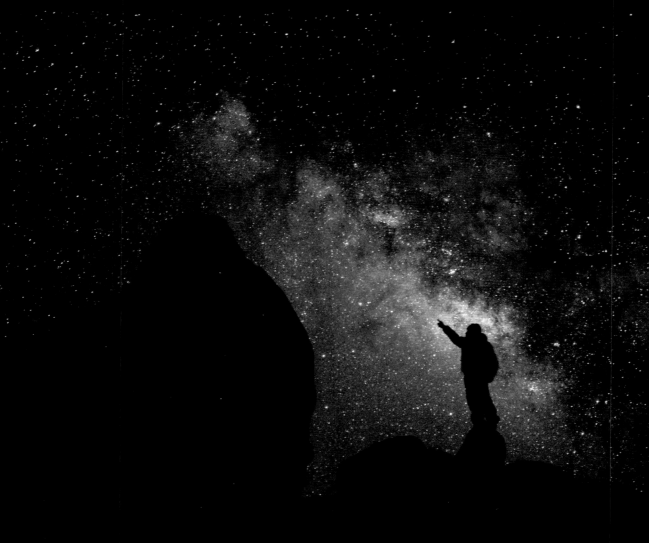

Stargazer's silhouette. April 18, 2010, 3:34 p.m.

While scouting out locations to photograph in the Alabama Hills near Mount Whitney in the eastern Sierra, my friend Justin climbed some large boulders and pointed to the sky, remarking on the sheer number of stars visible after midnight. "Hold that pose for twenty seconds!" I shouted, envisioning a great shot using an off-camera flash to illuminate him and the rocks under a moonless dark sky. My timing on the flash was late, and I thought I had ruined the shot until I looked at it closely and saw Justin's razor-sharp silhouette against the Milky Way.

Nikon D700; Nikkor 28 mm f/2.8 lens at f/4; 20-second single exposure at ISO 1600; mounted on Gitzo G1228 tripod

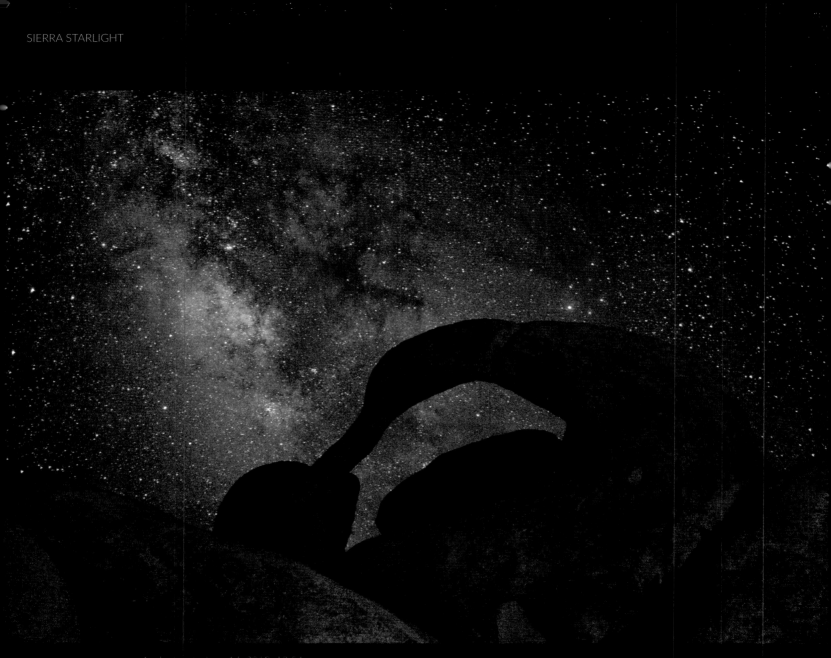

Ancient Arch, June 14, 2010, 12:54 a.m.

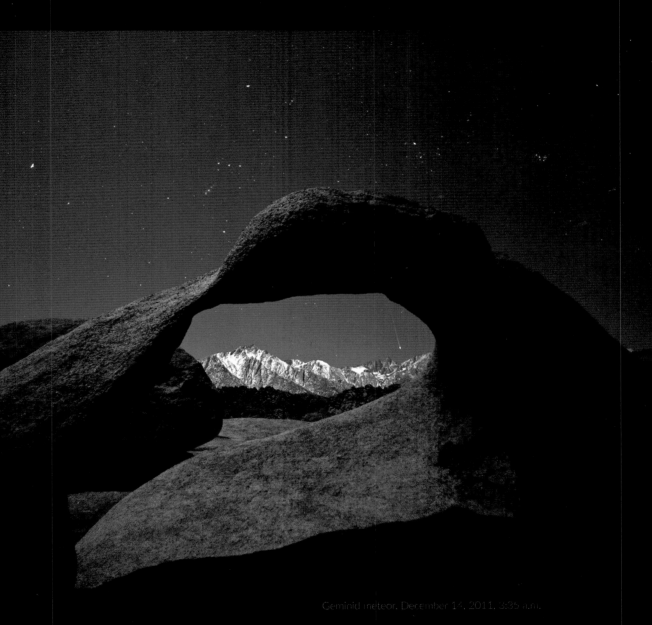

Geminid meteor, December 14, 2011, 3:35 a.m.

SEQUOIA NATIONAL PARK

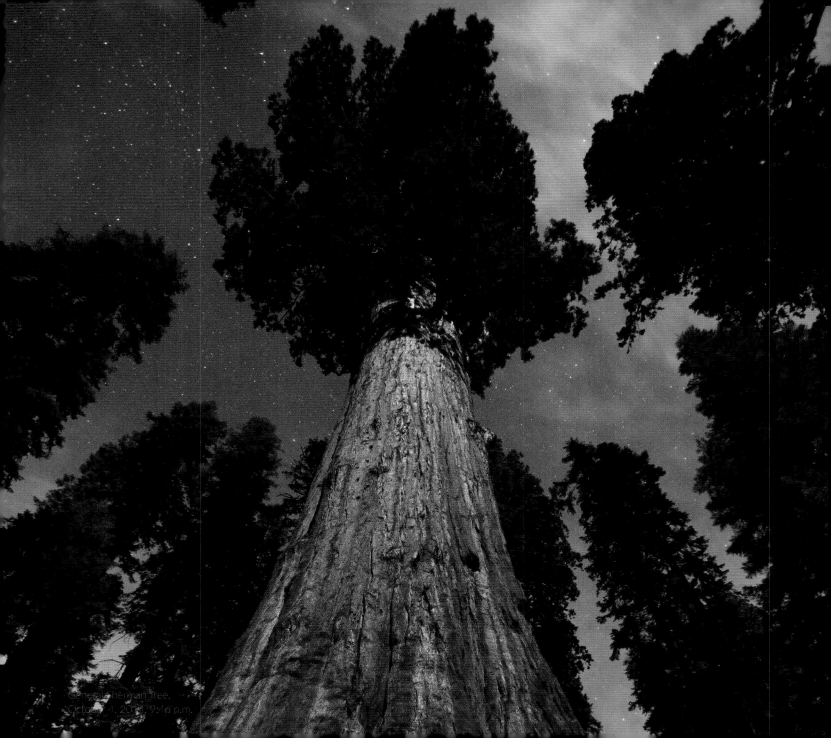

General Sherman Tree.
October 21, 2011, 9:16 p.m.

DEATH VALLEY

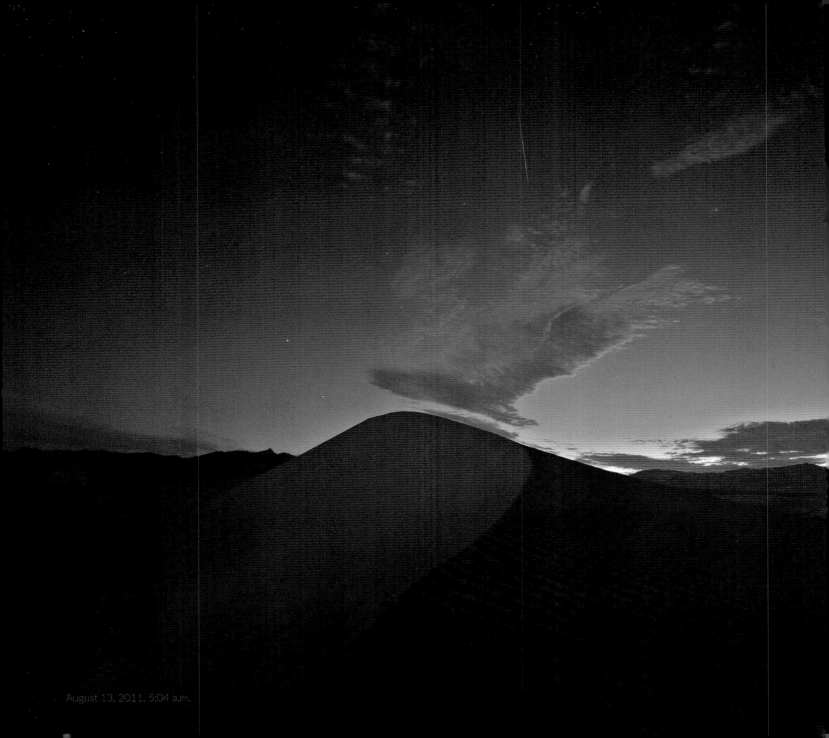

August 13, 2011, 5:04 a.m.

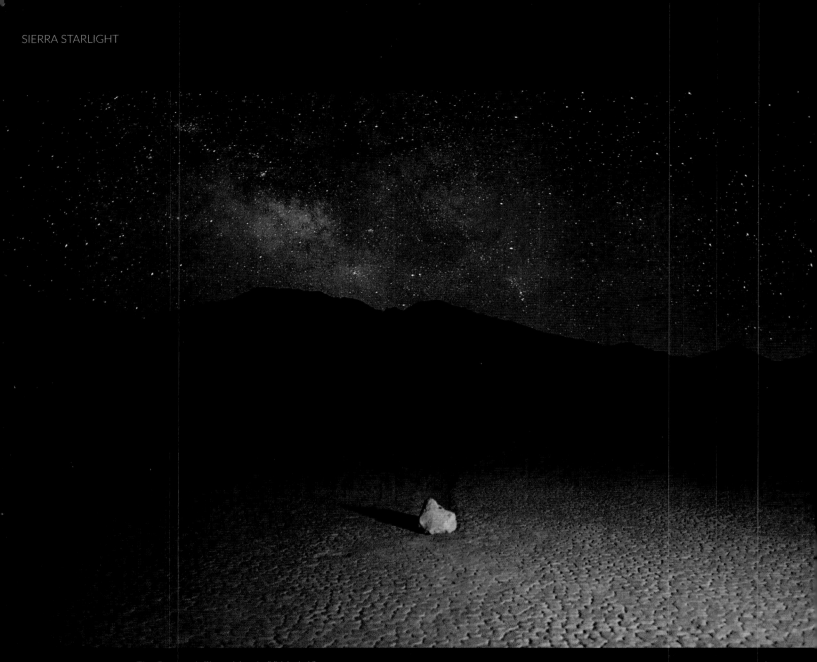

The Racetrack Playa, May 1, 2011, 1:42 a.m.

t was about to be the darkest night of the month in one of the darkest parts of the US—
an ideal destination for the astrophotographer. Death Valley's Racetrack Playa is an ee-
rily beautiful place, a flat expanse of earth so dry that the surface cracks into interlock-
ing hexagonal shapes. Mysterious "sailing stones" punctuate the landscape with their
comet-like tracks. Some of these rocks weigh up to six hundred pounds. They move without
human or animal intervention when scarce rainfall freezes and is followed by sunlight and
winds. On a moonless night, the darkness is absolute, and the black canvas of sky comes alive
with countless stars.

When I finally reached the ancient dry lake bed after twenty-six miles of off-roading in
my Jeep, the wind was fierce, whipping across the desert in a relentless barrage. I was plan-
ning on camping two nights and shooting hundreds of images with my camera mounted
on a three-foot motorized movie dolly for a time-lapse video. The first two nights were too
windy, so I only captured a few stills. I stayed on an extra night, and the winds finally calmed
down. If I was to get my time-lapse video it would have to be this night, as I was running
ow on water. I hiked nearly a mile to get to a particular rock that I had seen earlier that day
and carefully set up my equipment. Minutes later, while adjusting my composition, I heard a
heart-sinking *crack*. A screw that attaches the ball head had snapped off. I exhaled slowly and
seriously considered giving up, until I remembered that I had brought some tools and tape
n my backpack. I duct-taped the ball head and used zip ties to hold it to the platform of the
dolly. It wasn't elegant, but by the end of the night I had a stable time-lapse that included
the shot you see here.

*Nikon D700; Nikkor 24 mm f/2.8 lens at f/4; 18-second single exposure at ISO 2500; mounted on
Kessler Crane motorized Pocket Dolly*

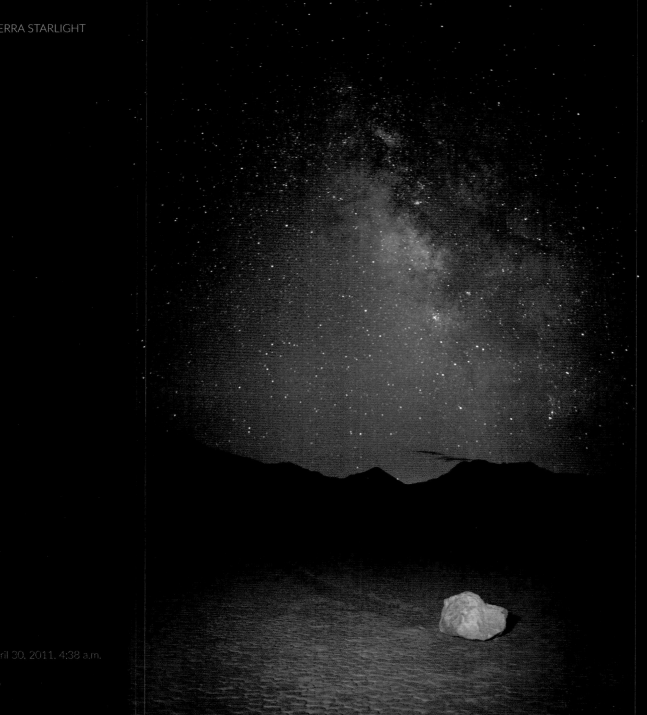

April 30, 2011, 4:38 a.m.

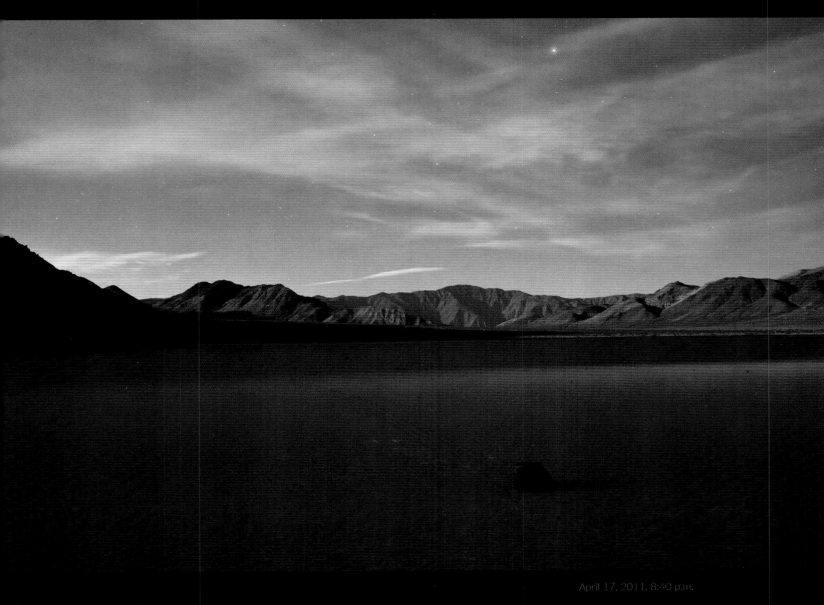

April 17, 2011. 8:40 p.m.

MOJAVE
DESERT

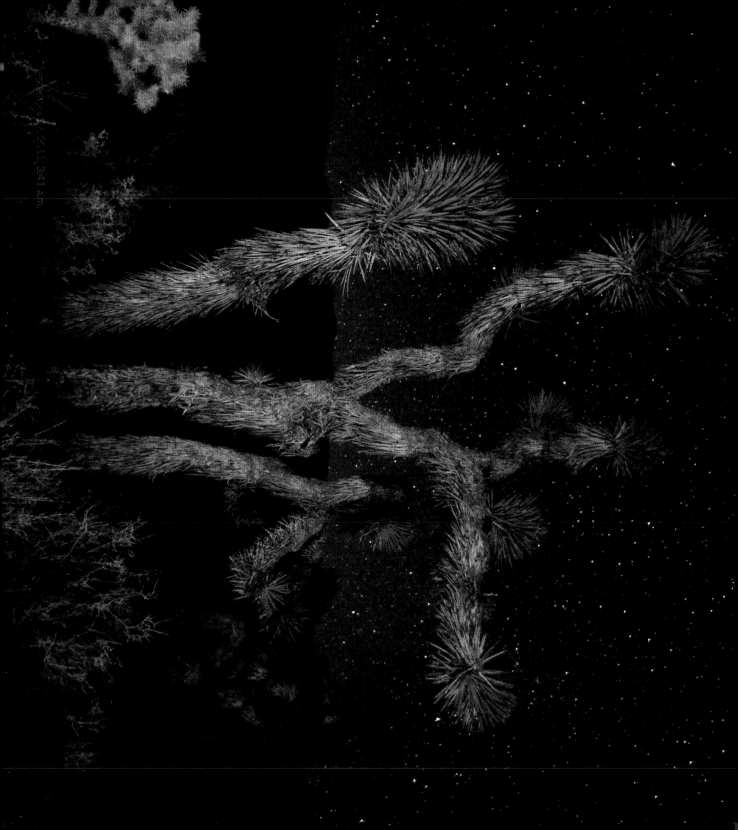

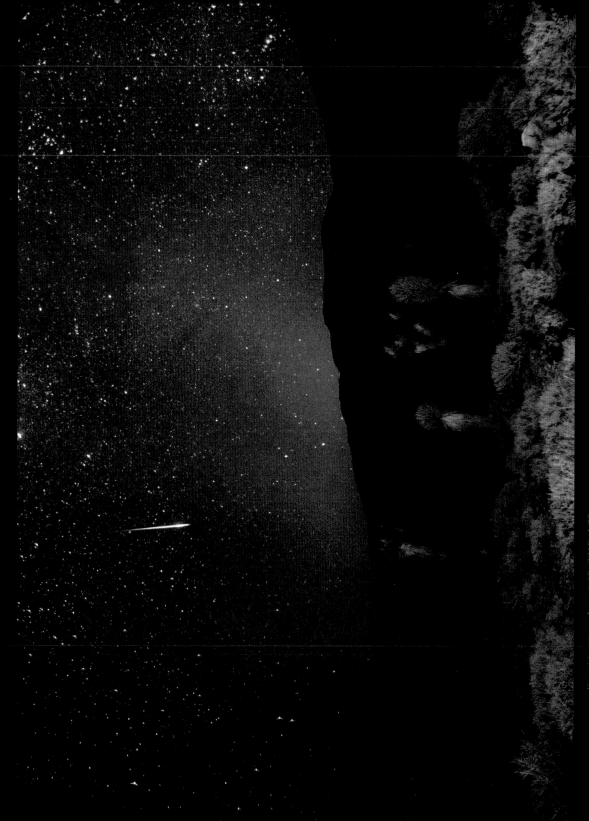

Perseid meteor, August 12, 2010, 4:28 a.m.

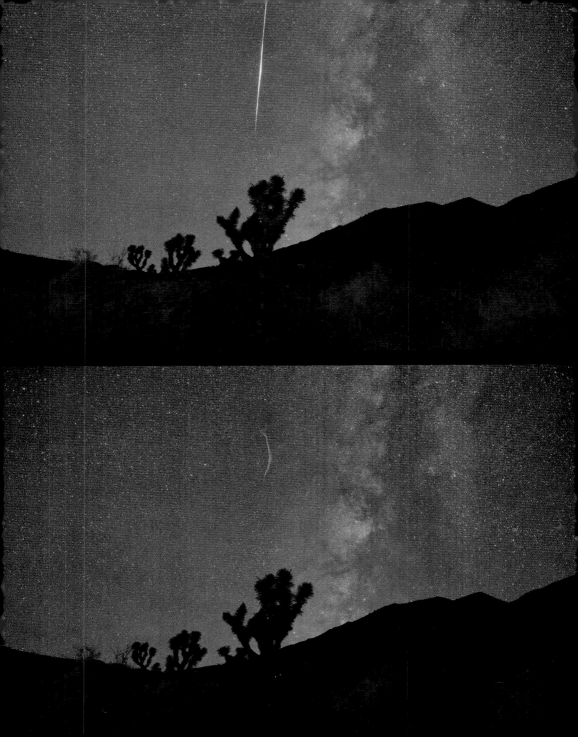

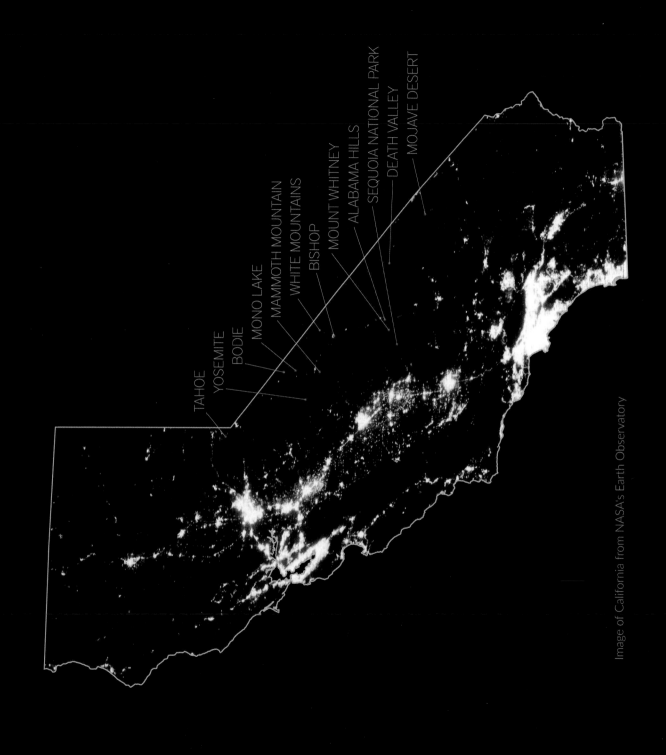

TAHOE
YOSEMITE
BODIE
MONO LAKE
MAMMOTH MOUNTAIN
WHITE MOUNTAINS
BISHOP
MOUNT WHITNEY
ALABAMA HILLS
SEQUOIA NATIONAL PARK
DEATH VALLEY
MOJAVE DESERT

Image of California from NASA's Earth Observatory

Note on Equipment

To get the best results from your astrophotography equipment, escape from the light pollution of major cities and venture to clearer skies. I have used Nikon cameras exclusively for over twenty-five years, and recently I have been shooting with the 36.3 MP Nikon D800 and D800E. These are fantastic cameras, and they handily include built-in intervalometers for time-lapse photography. As far as gear, my collection of equipment now includes three Nikon DSLRs (digital single-lens reflex cameras), Nikon D300s, D700, and D800E, with several Nikon and Nikkor lenses. I also use two Gitzo and two Manfrotto carbon-fiber tripods, a Celestron Advanced CG-5 mount, a Konus Digimax 90 scope and two Astro Hutech equatorial tracking mounts, two Kessler Crane motorized camera dolly systems, a Kessler Revolution robotic pan and tilt head, several SanDisk Extreme Pro 32 and 64 GB memory cards, and a MacBook Pro Laptop and Mac Pro computer with Adobe After Effects, Creative Suite, and Final Cut Studio software. The photos in this book are all single-exposure with minimal lightening, sharpening, and color adjustments.

Acknowledgments

I would like to thank the following people and organizations for their help with this book:

Carol Rowell
Galen Rowell
Margaret Rowell
Nicole Rowell Ryan
Ken Brower
Peter Beren
Astronomy magazine
Michael Bakich
David Eicher
Outdoor Photographer magazine
Steven Werner
Chris Robinson
Nikon USA
Michael Corrado
Lindsay Silverman
Malcolm Margolin and the staff of Heyday
Kevin Calder and the staff of Mountain
 Light Gallery
John Jancik and Terri Baker, The Echo
 Geophysical Corporation
David Anderson, Celestron Telescopes
Suguru Araki, professor of astrophysics at
 Tohoku Fukushi University in Japan
Christopher Kitting, California State University,
 East Bay
Sean Harnden
Ronald Goldgruber
Dan Spivey
Rick Nolthenius
Mike Cheuvront
Sam Sweiss, Parks Science and Astronomy Center

Tom Lowe, *TimeScapes*
Eric Kessler, Kessler Crane
Dave Hoch
East Bay Astronomical Society
The Sierra Club
Chabot Observatory
Jeff Sullivan
Sierra Maps and Robert Atlee
Tom Harrison Maps
Chris Langley and the Inyo County Film Commission
Lone Pine Chamber of Commerce
Lone Pine Film History Museum
Astro Hutech Corporation
Combined Array for Research in Millimeter-Wave
 Astronomy
The Astronomy Picture of the Day
Jose Francisco Salgado, Adler Planetarium
Bishop Office, Inyo National Forest
Bishop Field Office, Bureau of Land Management
Tawni Thomson and Joe Pollini, Bishop Chamber
 of Commerce
Barcroft High Altitude Research Station
Bodie State Park
David Ta-Wei Lin
Ancient Bristlecone Pine Forest Visitor Center
Death Valley National Park
Sequoia National Park
Yosemite National Park
Ron Cohen and the staff of the Tioga Pass Resort
Tioga Gas and Gift Mart
Lake Tahoe Nevada State Park

John and Patty Brissenden and the staff of
 Sorensen's Resort
Mono Lake Tufa State Natural Reserve
Alabama Hills Recreation Area
Russ Adams, Phillips Camera House in Bishop
Alex Printing in Bishop
Kevin Wright and the staff at Avant Printing
Bill and Zach Robinson, Sound Shoppe
 in Bishop
Lynne Almeida, Spellbinder Books
Todd Lassich
Trevor Anthes
Erick Bakkenta
Donna Bird
Jerry Bonnell
Paula Boxley
Cody Brown
Jason Crocket
Tanya Crocket
Guy Davis
Aaron and Emily Fischer
Bill Gates
Mike Hardiman
Jay Heapy from Martis Camp
Dustin Hurt
Dan Judy
Don Lauria
Jim Lozano
Dana LeFever
Ervin R. Lent
David Ta-Wei Lin

Robert Nemiroff
Phil Plait, Bad Astronomy
Alex Pollini and Pollini Productions
Gregg Pusateri
Paul Rasmussen
Nick Schley
Justin Whitman
Tim Winkler
Dakota Winkler

About the Author

Tony Rowell's award-winning photos have been published in books, calendars, and in *Astronomy*, *Backpacker*, *Mountain Bike Action*, and *Outdoor Photographer* magazines. His astro time-lapse videos have been featured on the National Geographic Channel, and his astrophotographs have been chosen for the Astronomy Picture of the Day on NASA's APOD website. Tony is the son of renowned photographer and mountaineer Galen Rowell, and like his father, Tony loves a good adventure. His photography expeditions have taken him from the Arctic Circle to the mountains of Tibet, and his work has been exhibited at the Yosemite Museum, the Marin Headlands Visitor Center, and the Mountain Light Gallery near his home in Bishop in California's beautiful eastern Sierra. Tony's fine art prints are available for purchase online at TonyRowell.com.

HEYDAY

ABOUT HEYDAY

Heyday is an independent, nonprofit publisher and unique cultural institution. We promote widespread awareness and celebration of California's many cultures, landscapes, and boundary-breaking ideas. Through our well-crafted books, public events, and innovative outreach programs we are building a vibrant community of readers, writers, and thinkers.

THANK YOU

It takes the collective effort of many to create a thriving literary culture. We are thankful to all the thoughtful people we have the privilege to engage with. Cheers to our writers, artists, editors, storytellers, designers, printers, bookstores, critics, cultural organizations, readers, and book lovers everywhere!

We are especially grateful for the generous funding we've received for our publications and programs during the past year from foundations and hundreds of individual donors. Major supporters include:

Alliance for California Traditional Arts; Anonymous (6); Arkay Foundation; Judith and Phillip Auth; Judy Avery; Carol Baird and Alan Harper; Paul Bancroft III; The Bancroft Library; Richard and Rickie Ann Baum; BayTree Fund; S. D. Bechtel, Jr. Foundation; Jean and Fred Berensmeier; Berkeley Civic Arts Program and Civic Arts Commission; Joan Berman; Nancy Bertelsen; Barbara Boucke; Beatrice Bowles, in memory of Susan S. Lake; John Briscoe; David Brower Center; Lewis and Sheana Butler; Helen Cagampang; California Historical Society; California Indian Heritage Center Foundation; California State Parks Foundation; Joanne Campbell; The Campbell Foundation; James and Margaret Chapin; Graham Chisholm; The Christensen Fund; Jon Christensen; Cynthia Clarke; Community Futures Collective; Lawrence Crooks; Lauren and Alan Dachs; Nik Dehejia; Topher Delaney; Chris Desser and Kirk Marckwald; Lokelani Devone; Frances Dinkelspiel and Gary Wayne; Doune Fund; The Durfee Foundation; Megan Fletcher and J.K. Dineen; Michael Eaton and Charity Kenyon; Richard and Gretchen Evans; Flow Fund Circle; Friends of the Roseville Library; Furthur Foundation; The Wallace Alexander Gerbode Foundation; Patrick Golden; Nicola W. Gordon; Wanda Lee Graves and Stephen Duscha; The Walter and Elise Haas Fund; Coke and James Hallowell; Theresa Harlan and Ken Tiger; Cindy Heitzman; Carla Hills; Sandra and Charles Hobson; Nettie

Hoge; Donna Ewald Huggins; JiJi Foundation; Claudia Jurmain; Kalliopeia Foundation; Lowry and Croul; Marty and Pamela Krasney; Robert and Karen Kustel; Guy Lampard and Suzanne Badenhoop; Thomas Lockard and Alix Marduel; Thomas J. Long Foundation; Bryce Lundberg; Sam and Alfreda Maloof Foundation for Arts & Crafts; Michael McCone; Giles W. and Elise G. Mead Foundation; Moore Family Foundation; Michael J. Moratto, in memory of Major J. Moratto; Stewart R. Mott Foundation; The MSB Charitable Fund; Karen and Thomas Mulvaney; Richard Nagler; National Wildlife Federation; Native Arts and Cultures Foundation; Humboldt Area Foundation, Native Cultures Fund; The Nature Conservancy; Nightingale Family Foundation; Steven Nightingale and Lucy Blake; Northern California Water Association; Ohlone-Costanoan Esselen Nation; Panta Rhea Foundation; David Plant; Jean Pokorny; Steven Rasmussen and Felicia Woytak; Restore Hetch Hetchy; Robin Ridder; Spreck and Isabella Rosekrans; Alan Rosenus; The San Francisco Foundation; Toby and Sheila Schwartzburg; Sierra College; Stephen M. Silberstein Foundation; Ernest and June Siva, in honor of the Dorothy Ramon Learning Center; Carla Soracco; John and Beverly Stauffer Foundation; Radha Stern, in honor of Malcolm Margolin and Diane Lee; Roselyne Chroman Swig; TomKat Charitable Trust; Tides Foundation; Sonia Torres; Michael and Shirley Traynor; The Roger J. and Madeleine Traynor Foundation; Lisa Van Cleef and Mark Gunson; Patricia Wakida; John Wiley & Sons, Inc.; Peter Booth Wiley and Valerie Barth; Bobby Winston; Dean Witter Foundation; Yocha Dehe Wintun Nation; and Yosemite Conservancy.

BOARD OF DIRECTORS

GETTING INVOLVED

To learn more about our publications, events, membership club, and other ways you can participate, please visit www.heydaybooks.com.